WE'RE ALL MAD HERE

madhere.store

ARE YOU READY TO COLOR OUTSIDE THE LINES OF REALITY

A Twisted Wonderland Coloring Book Series

Prepare to journey down the rabbit hole and into a world that defies imagination with our chilling and captivating coloring book series. "We're All Mad Here." Designed exclusively for adults, this series draws inspiration from the beloved "Alice in Wonderland" while embracing the eerie and unsettling aspects of Lewis Carroll's tale.

Step into a Wonderland that has been warped into a nightmarish realm, where whimsical characters take on a haunting and spine-tingling appearance. In "We're All Mad Here," the Mad Hatter's tea party is a sinister gathering of ghoulish guests, the White Rabbit is a spectral figure leading Alice into the unknown, and the Cheshire Cat's smile is a malevolent grin lurking in the shadows.

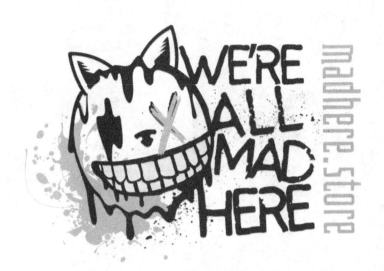

A big thank you from "We're All Mad Here"!

Your support means the world to us. and we're truly grateful for your purchase.

Follow us on our Facebook page
"We're All Mad Here"(madhere.store)
for the latest updates and behind-the-scenes madness.
Don't forget to check out our merch shop at
madhere.store
For more whimsical wonders

Enjoy the madness!

and remember. in our world. it's perfectly fine to color outside the lines.
After all. we're all a little mad here. aren't we?

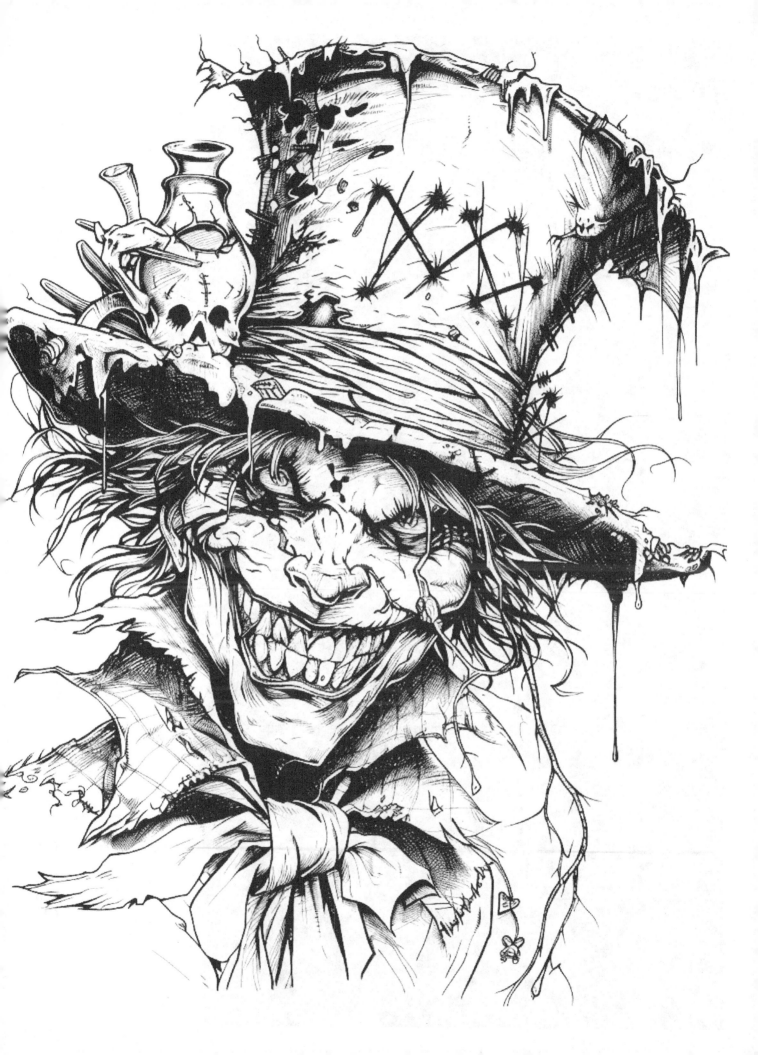

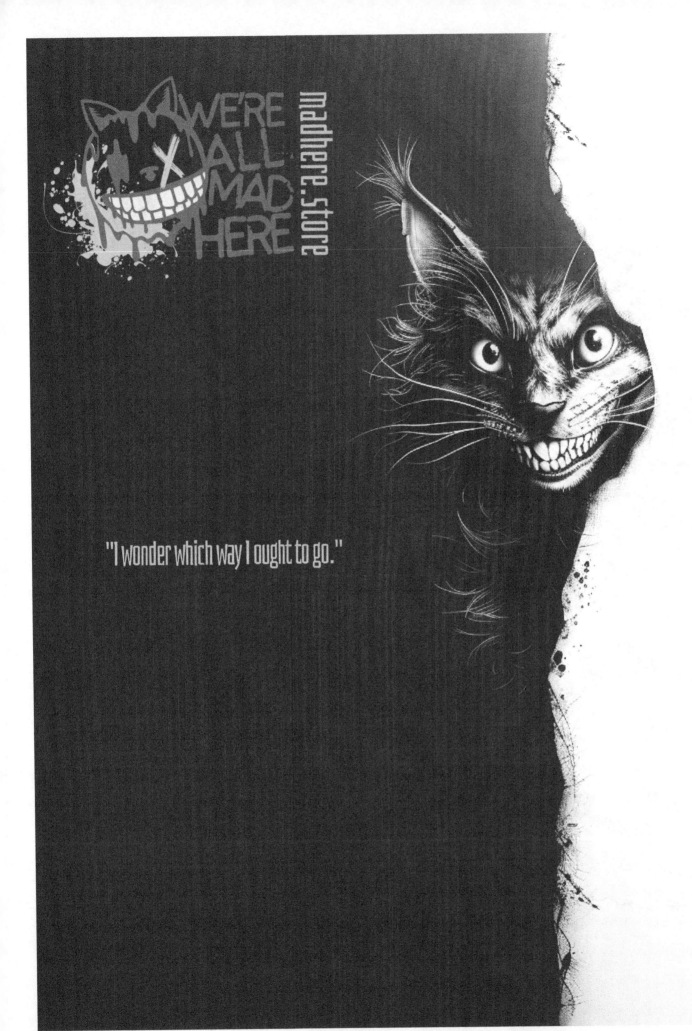

WE'RE ALL MAD HERE

madhere.store

"I wonder which way I ought to go."

ARE YOU READY TO COLOR OUTSIDE THE LINES OF REALITY?

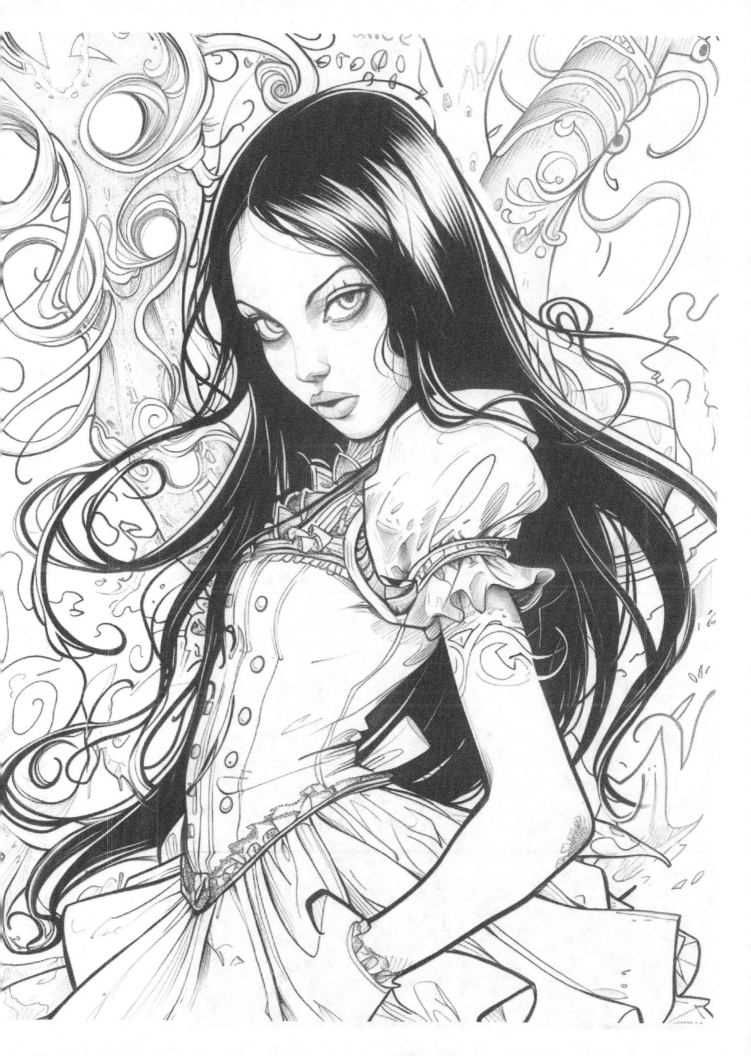

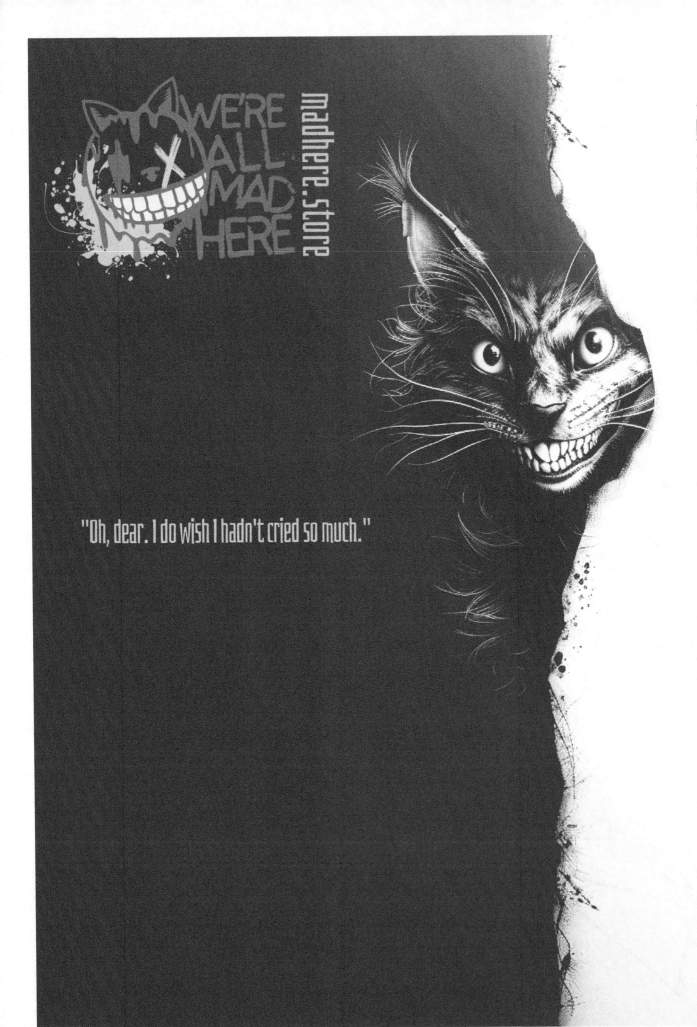

WE'RE ALL MAD HERE

madhere.store

"Oh, dear. I do wish I hadn't cried so much."

ARE YOU READY TO COLOR OUTSIDE THE LINES OF REALITY?

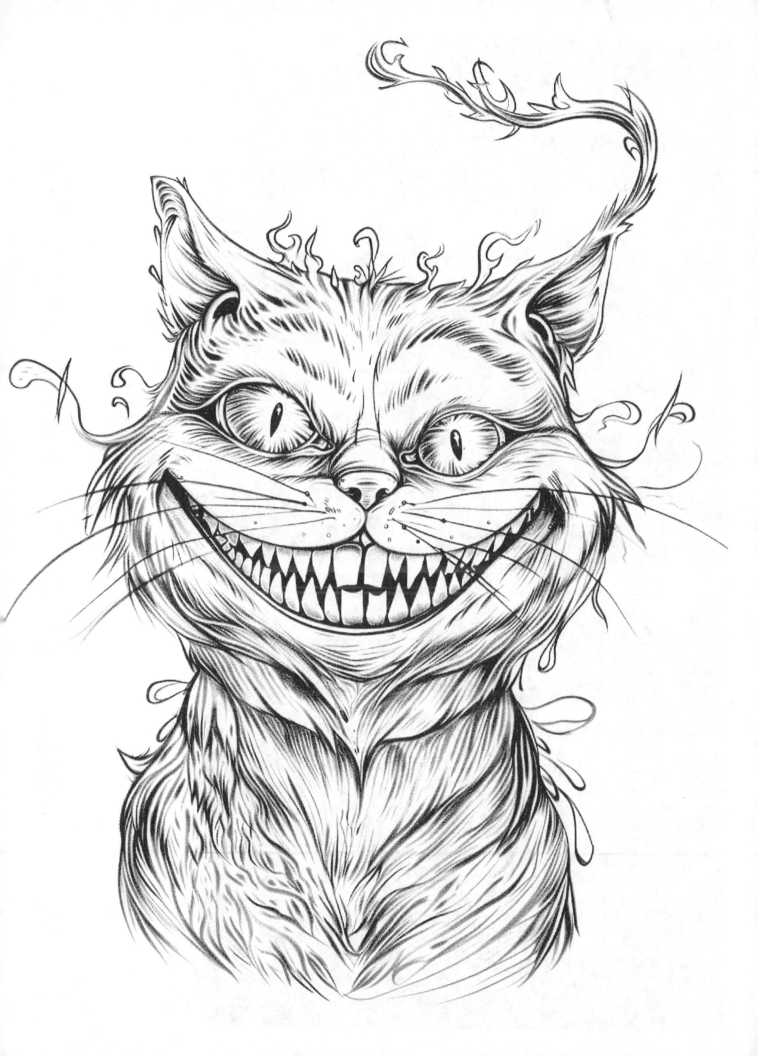

WE'RE ALL MAD HERE

madhere.store

"It would be so nice if something made sense for a change."

ARE YOU READY TO COLOR OUTSIDE THE LINES OF REALITY?

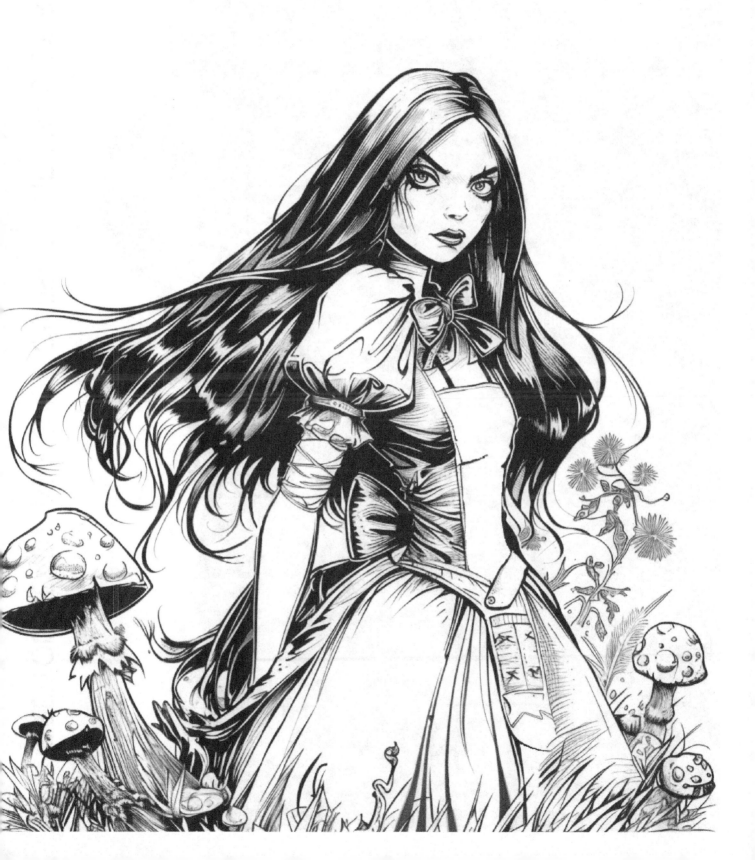

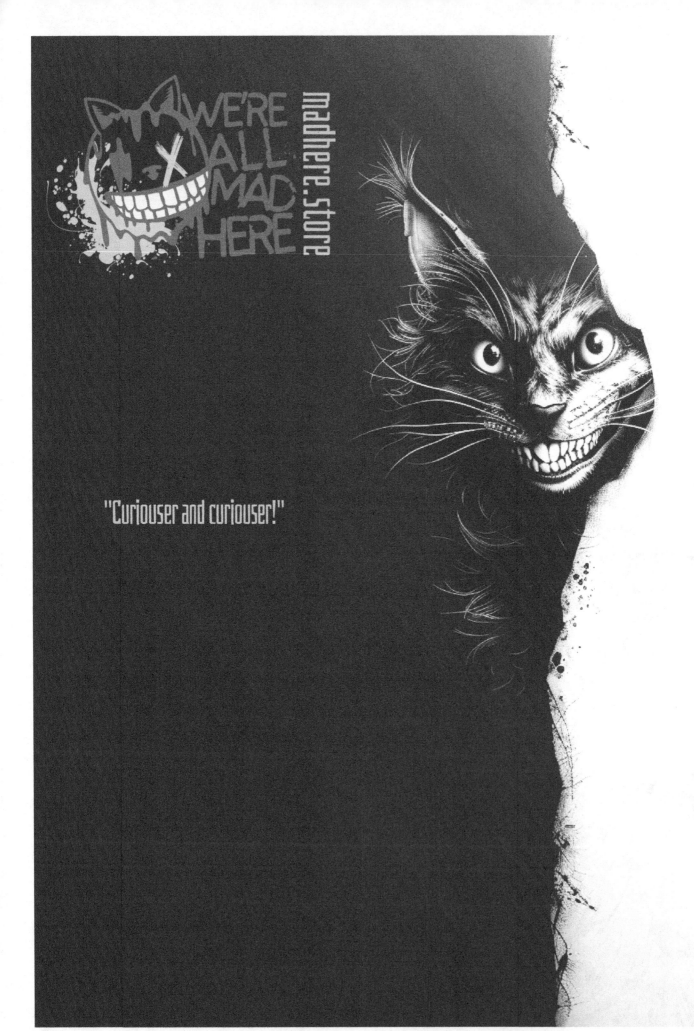

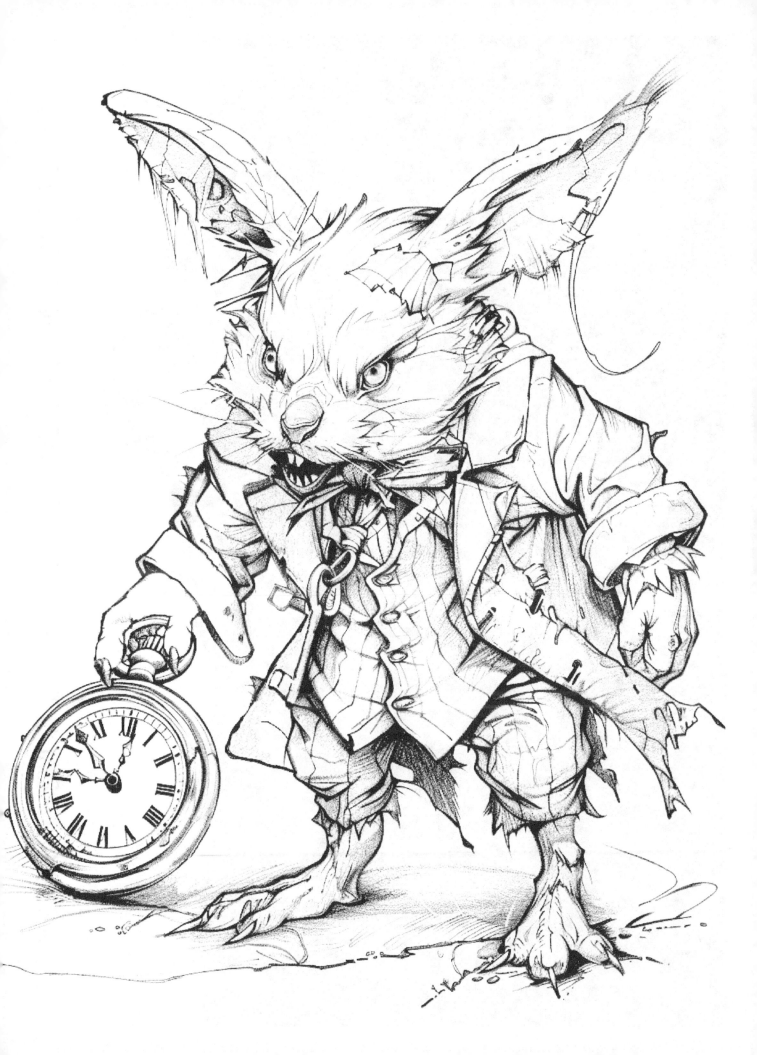

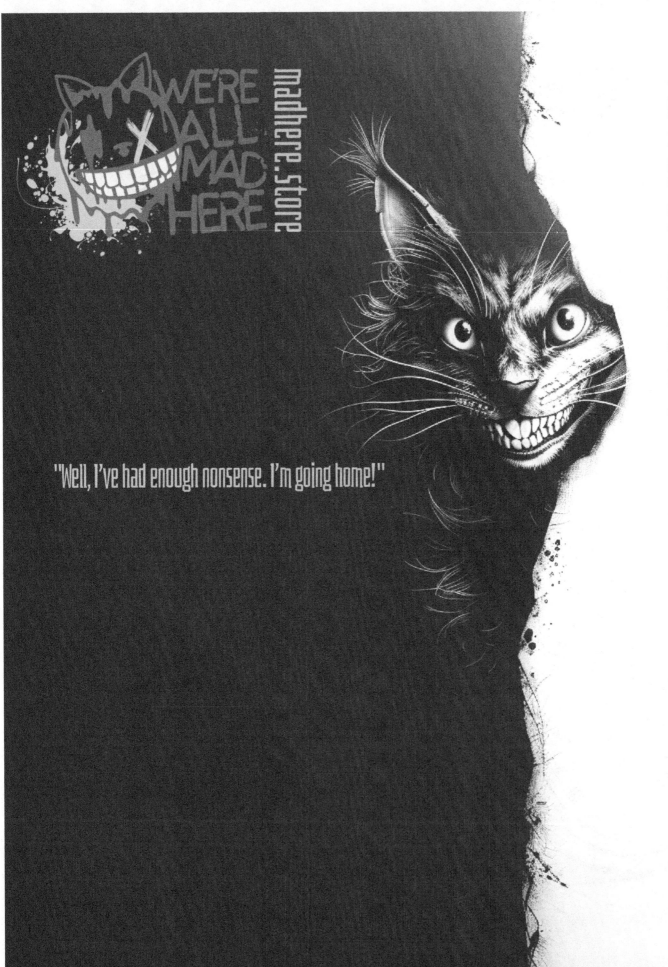

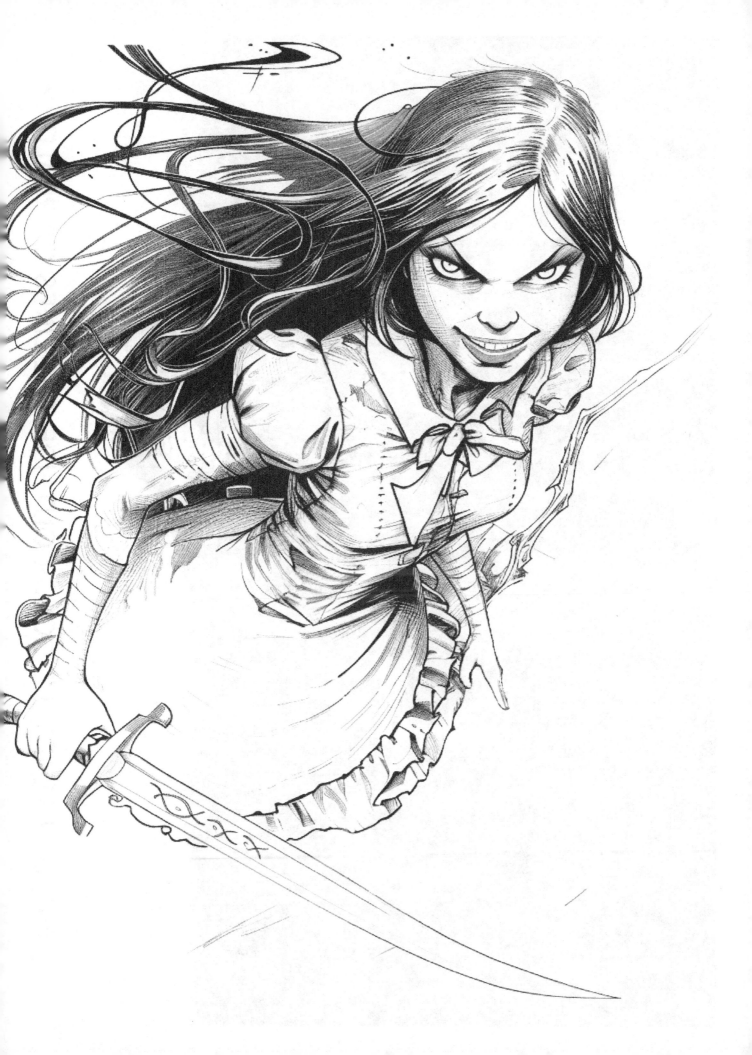

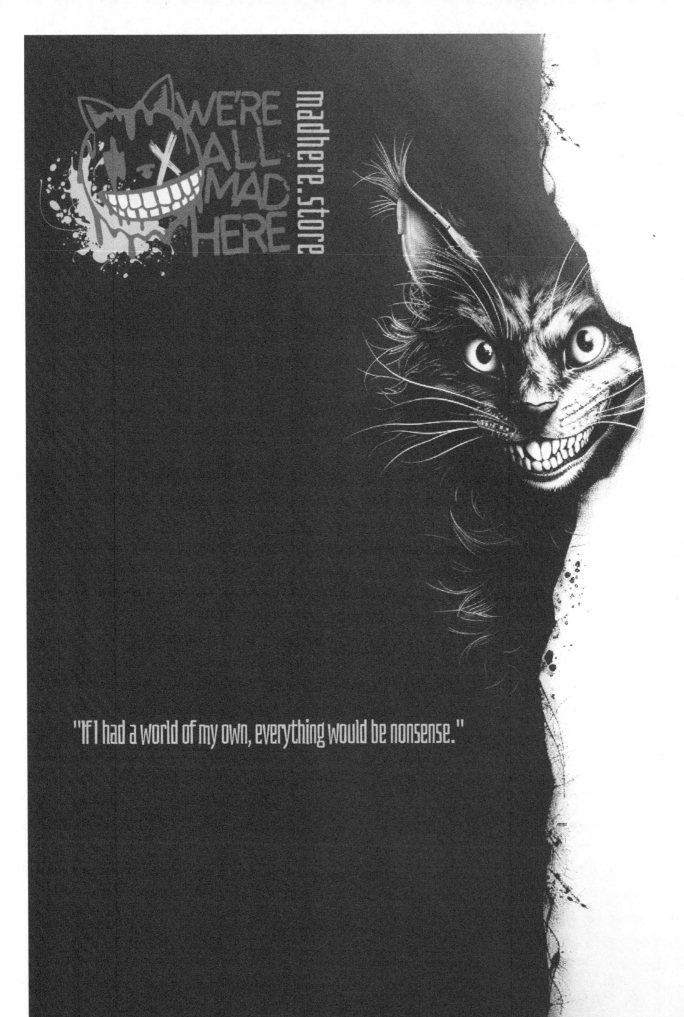

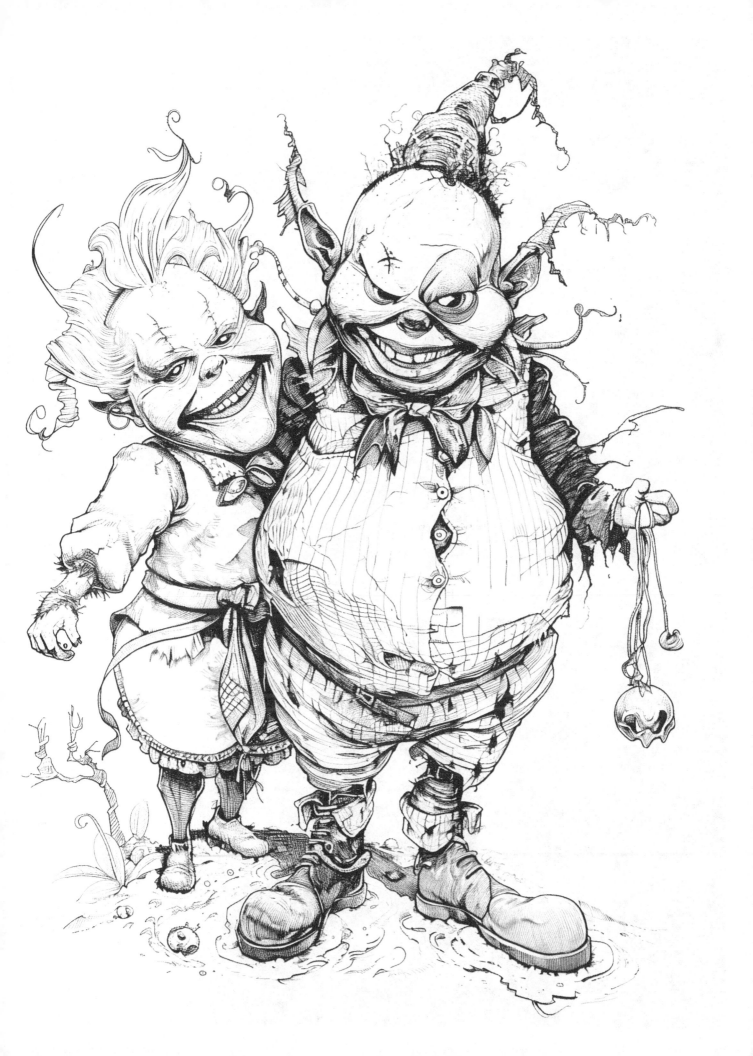

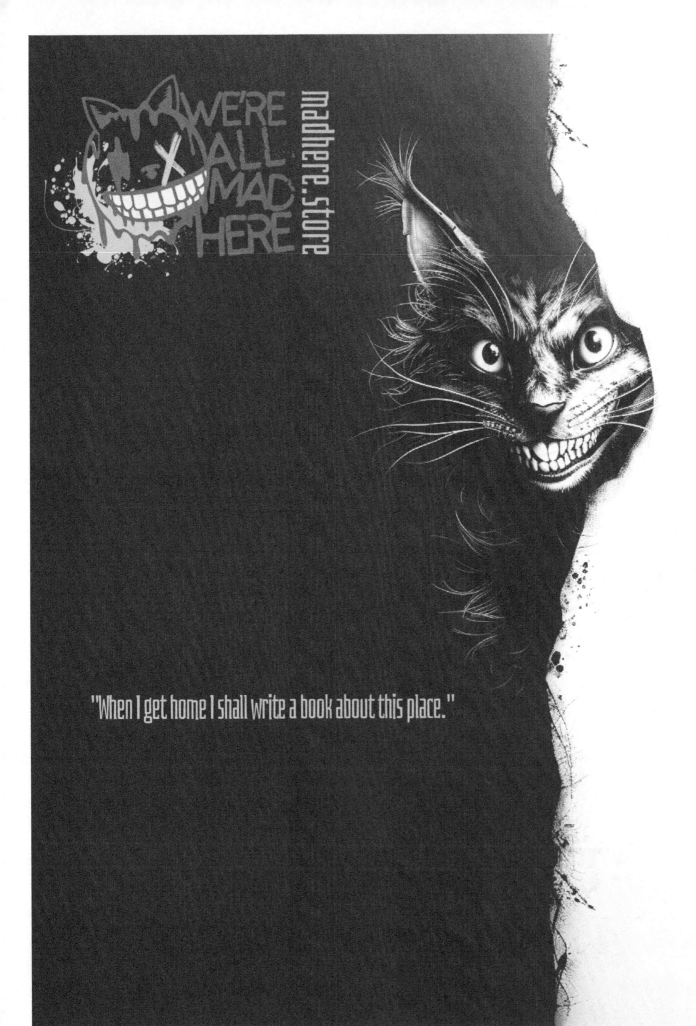

WE'RE ALL MAD HERE

madhere.store

"When I get home I shall write a book about this place."

ARE YOU READY TO COLOR OUTSIDE THE LINES OF REALITY?

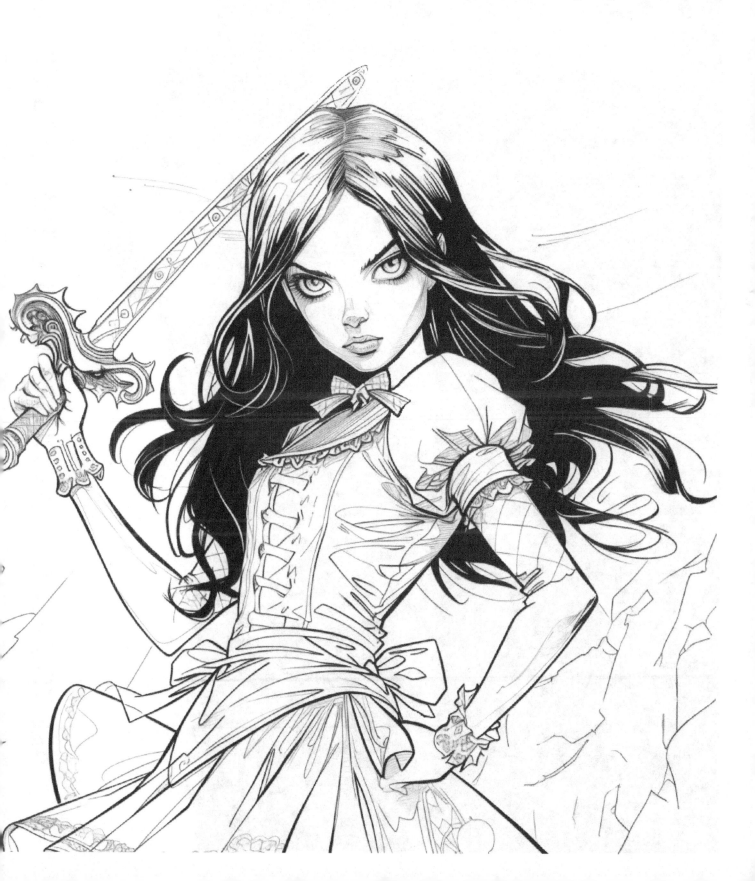

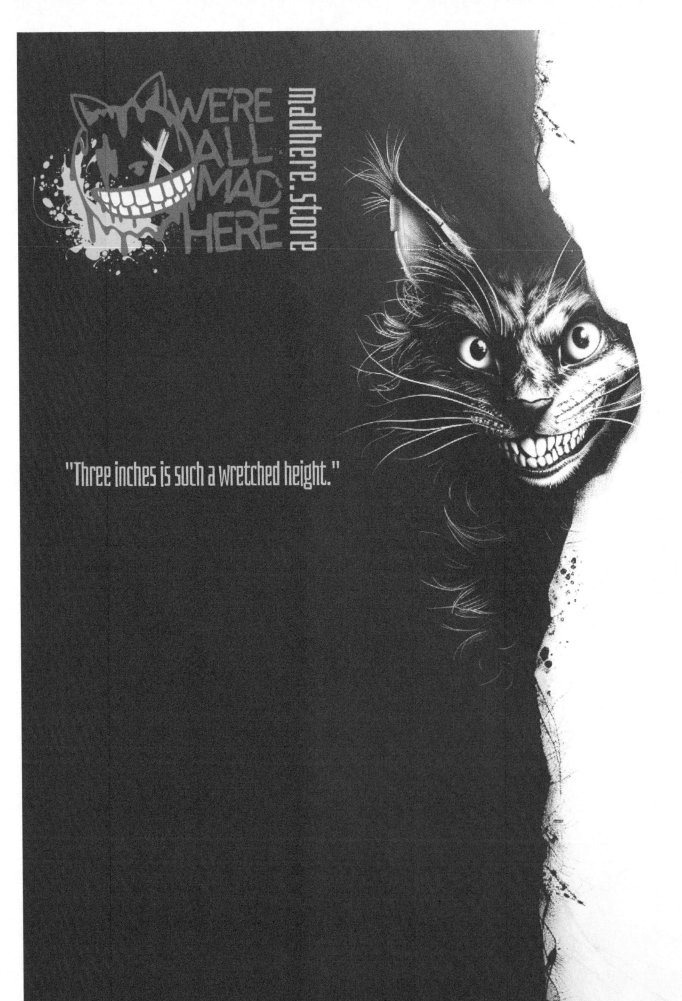

"Three inches is such a wretched height."

ARE YOU READY TO COLOR OUTSIDE THE LINES OF REALITY?

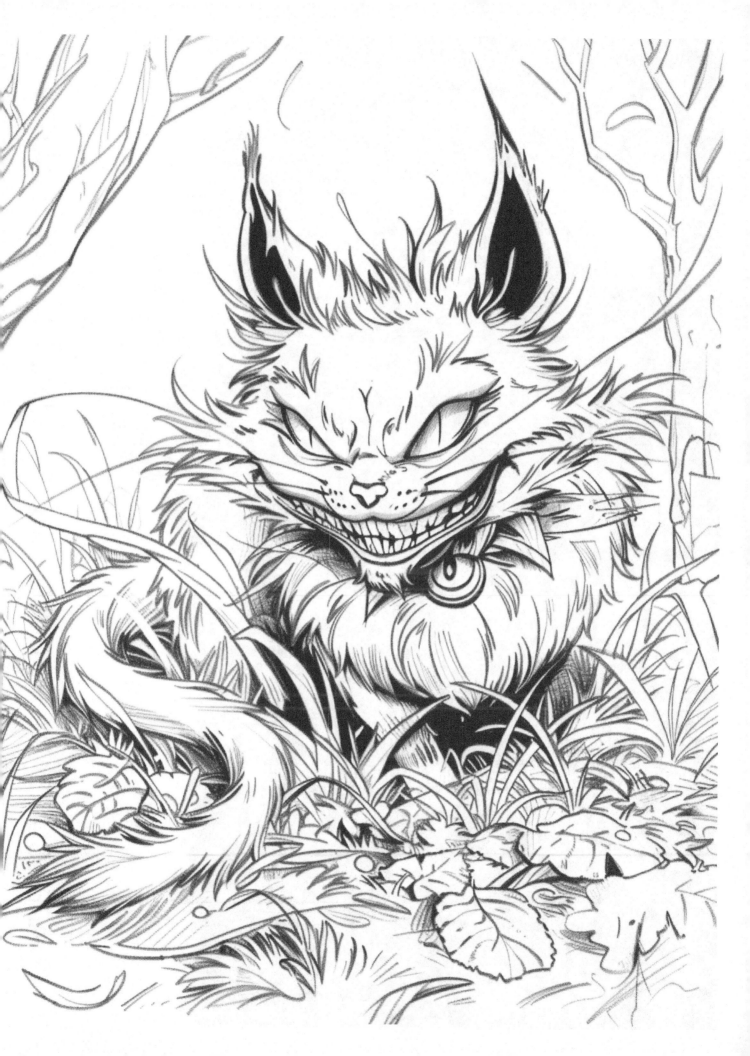

WE'RE ALL MAD HERE

madhere.store

"I'm afraid I can't explain myself, sir. Because I'm not myself, you know."

ARE YOU READY TO COLOR OUTSIDE THE LINES OF REALITY?

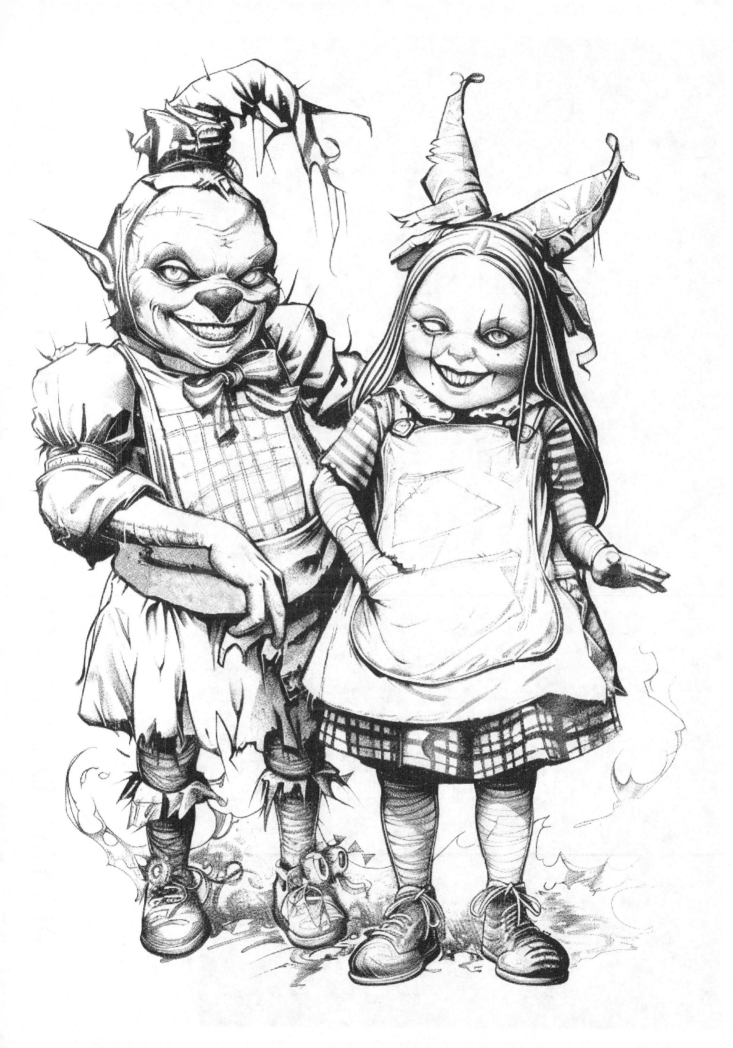

WE'RE ALL MAD HERE

madhere.store

"But how can one possibly pay attention to a book with no pictures in it?"

ARE YOU READY TO COLOR OUTSIDE THE LINES OF REALITY?

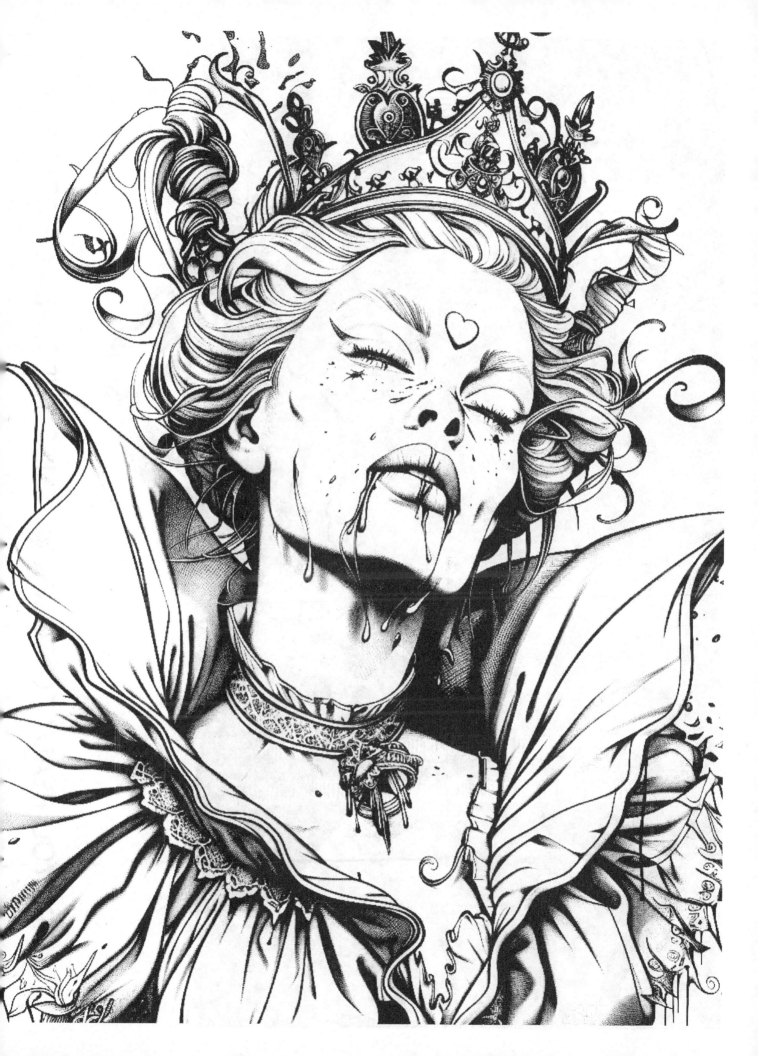

WE'RE ALL MAD HERE

madhere.store

"For if one drinks much from a bottle marked 'poison,' it's almost certain to disagree with one sooner or later."

ARE YOU READY TO COLOR OUTSIDE THE LINES OF REALITY?

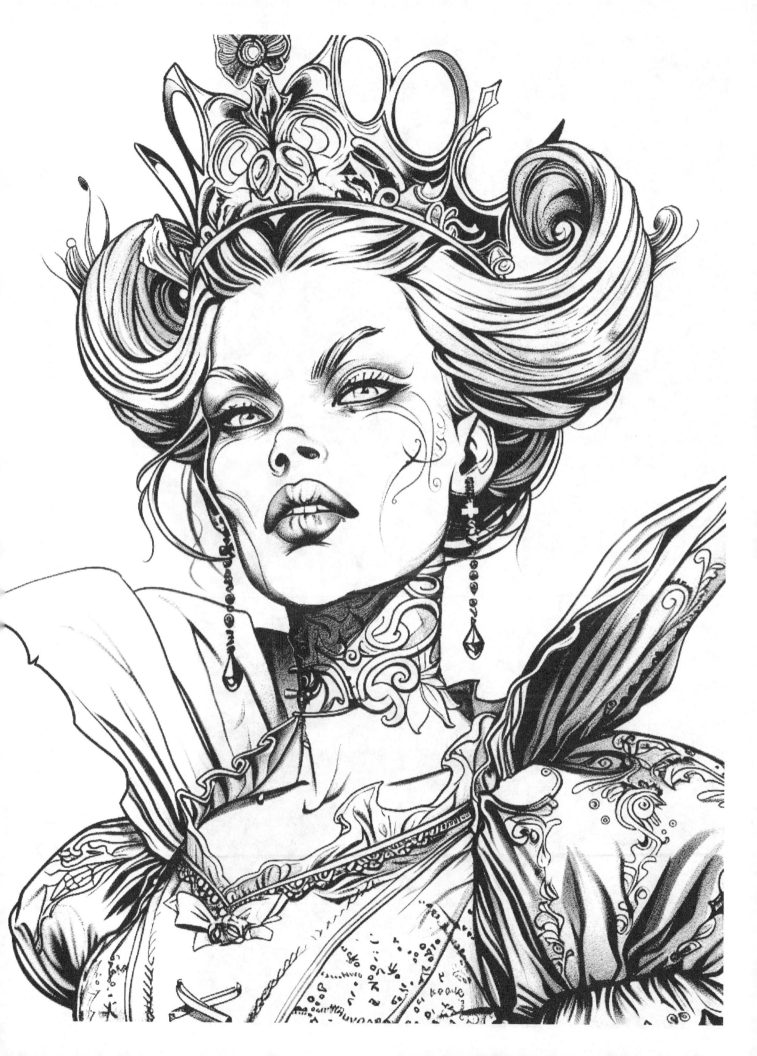

WE'RE ALL MAD HERE

madhere.store

"Well, I can't put it any more clearly, sir, for it isn't clear to me."

ARE YOU READY TO COLOR OUTSIDE THE LINES OF REALITY?

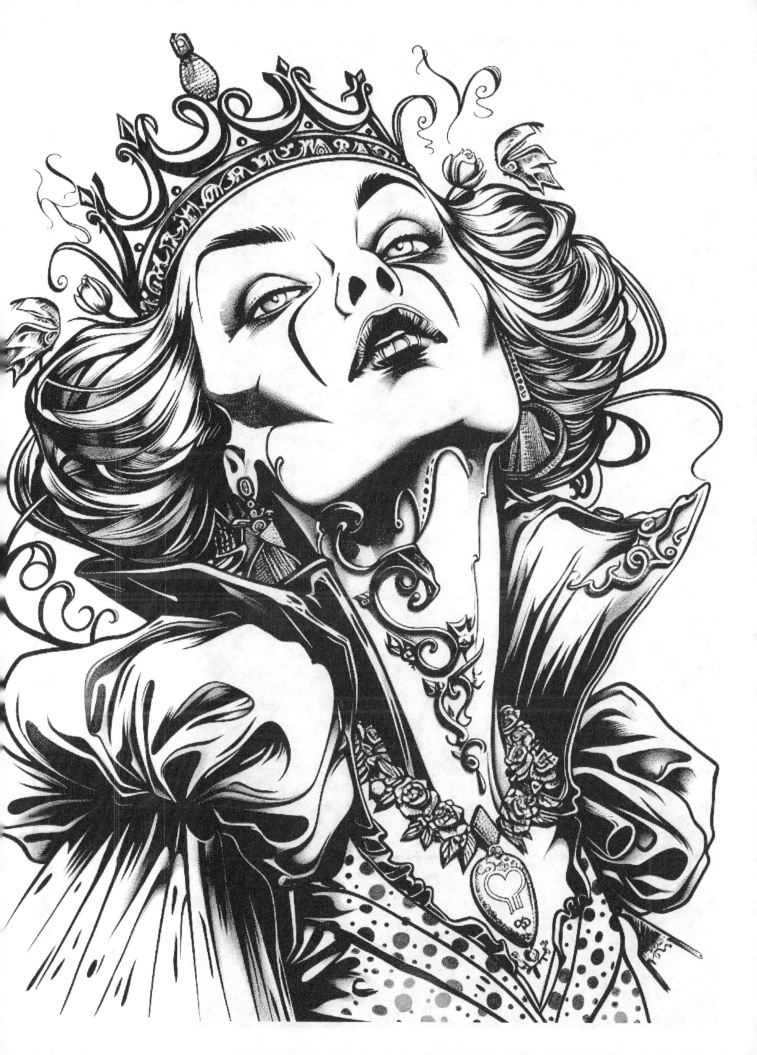

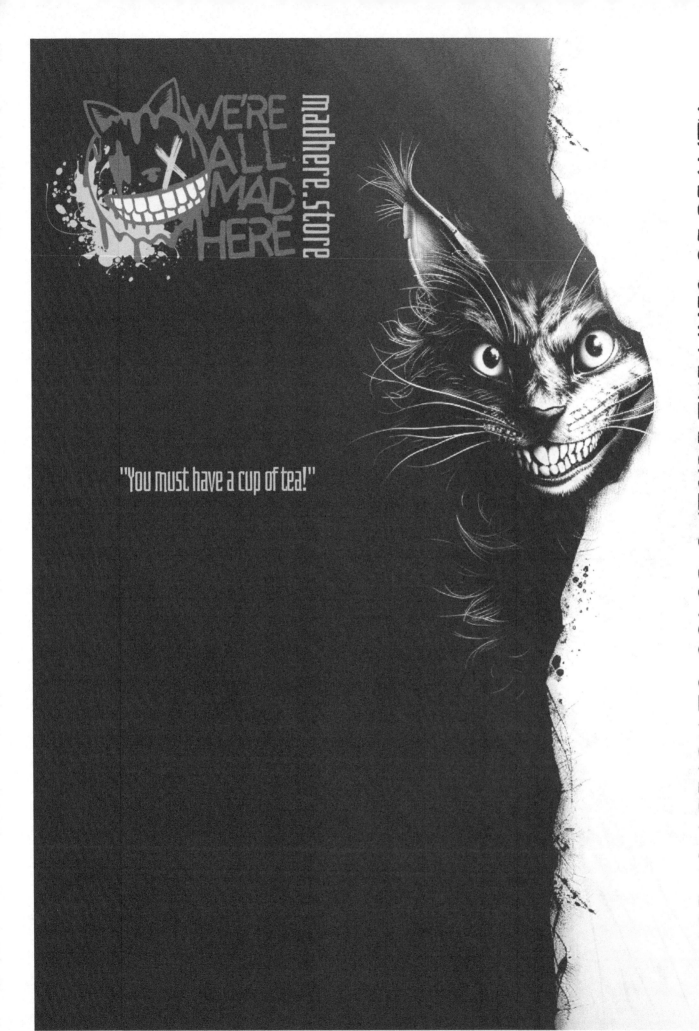

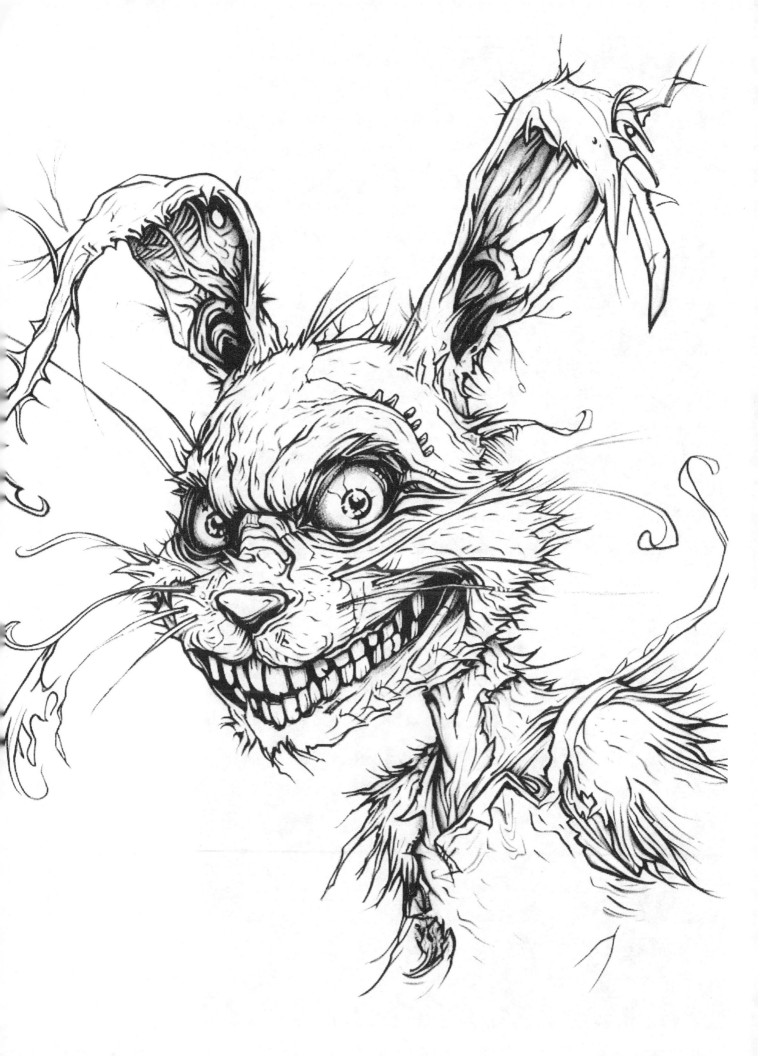

WE'RE ALL MAD HERE

madhere.store

"Twinkle twinkle little bat. How I wonder what you're at. Up and above the world you fly, like a tea tray in the sky."

ARE YOU READY TO COLOR OUTSIDE THE LINES OF REALITY?

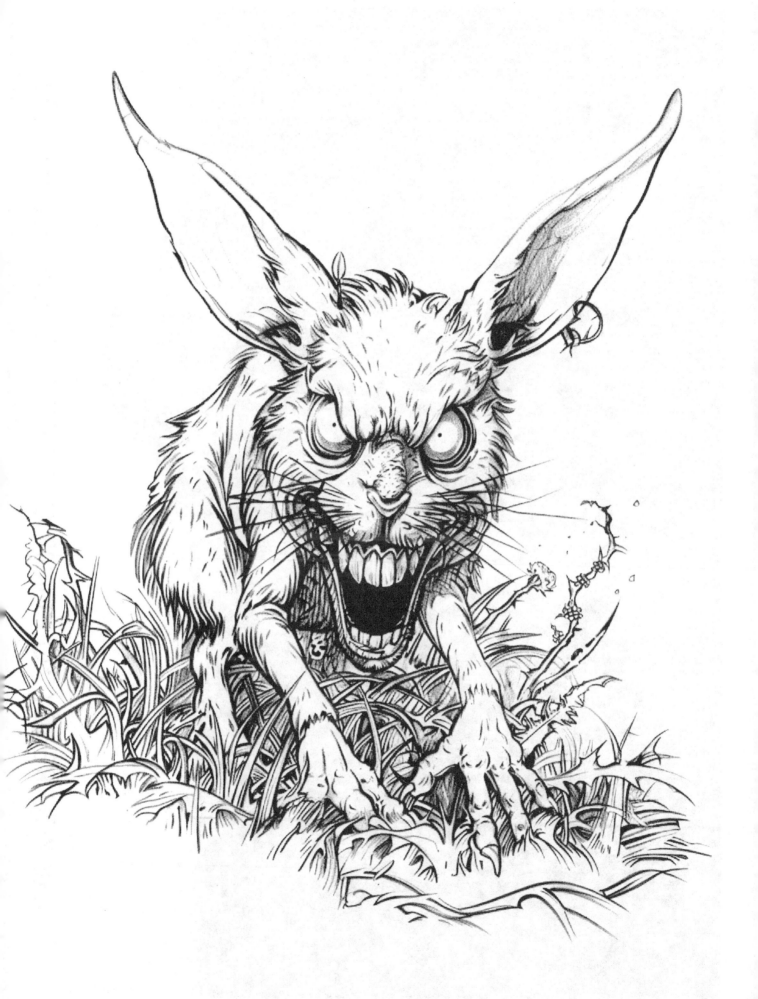

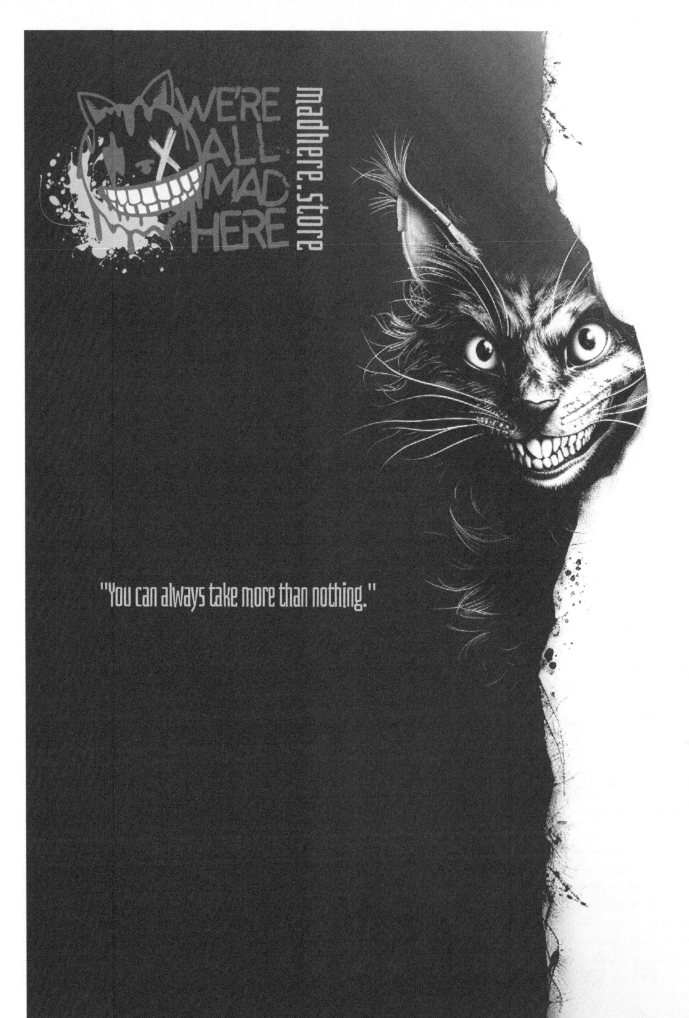

WE'RE ALL MAD HERE

madhere.store

"You can always take more than nothing."

ARE YOU READY TO COLOR OUTSIDE THE LINES OF REALITY?

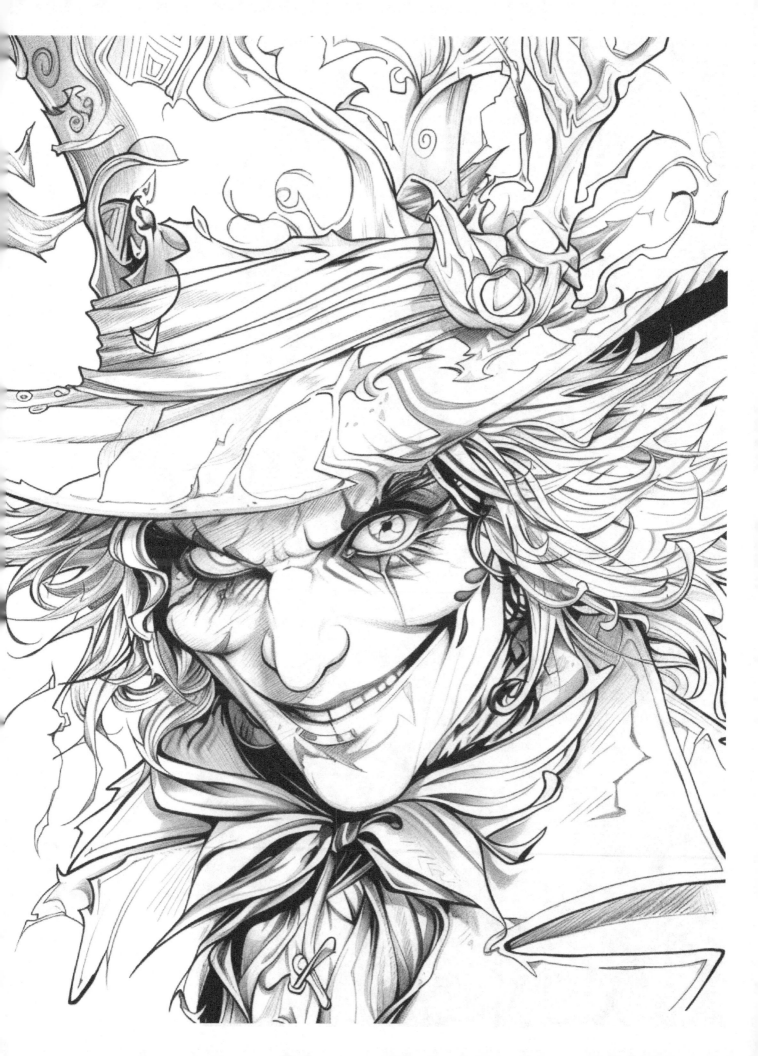

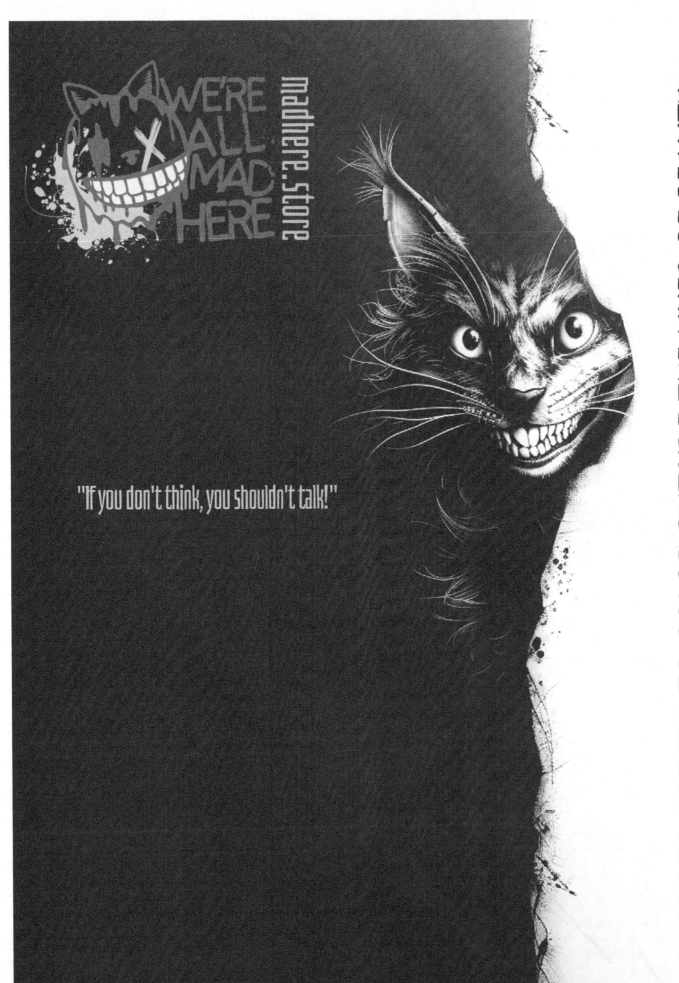

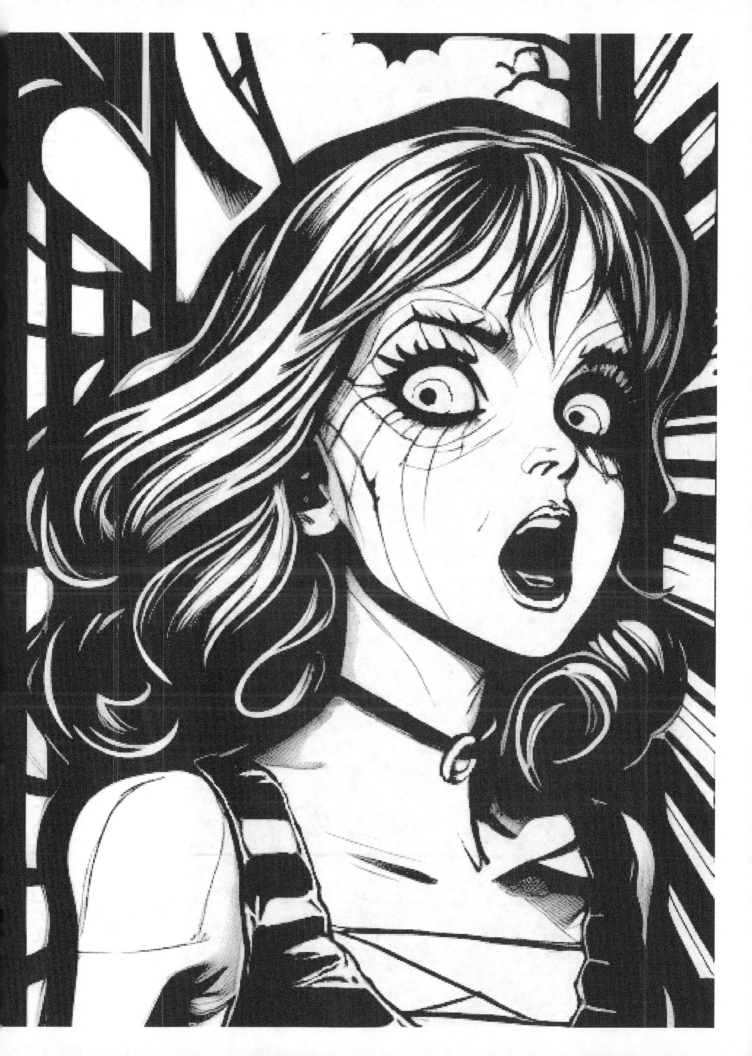

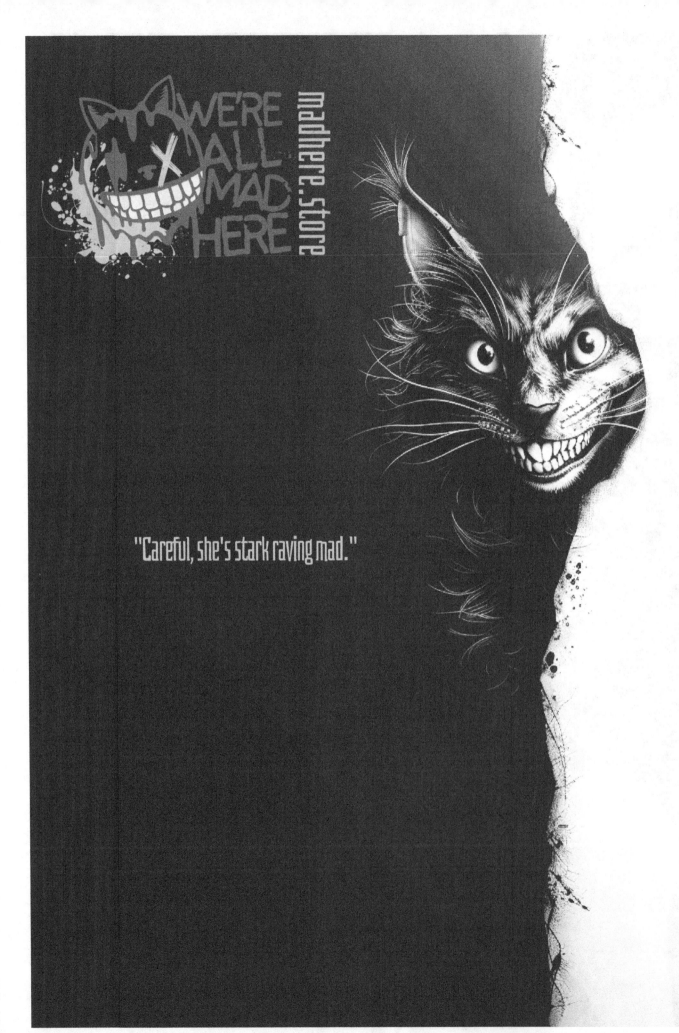

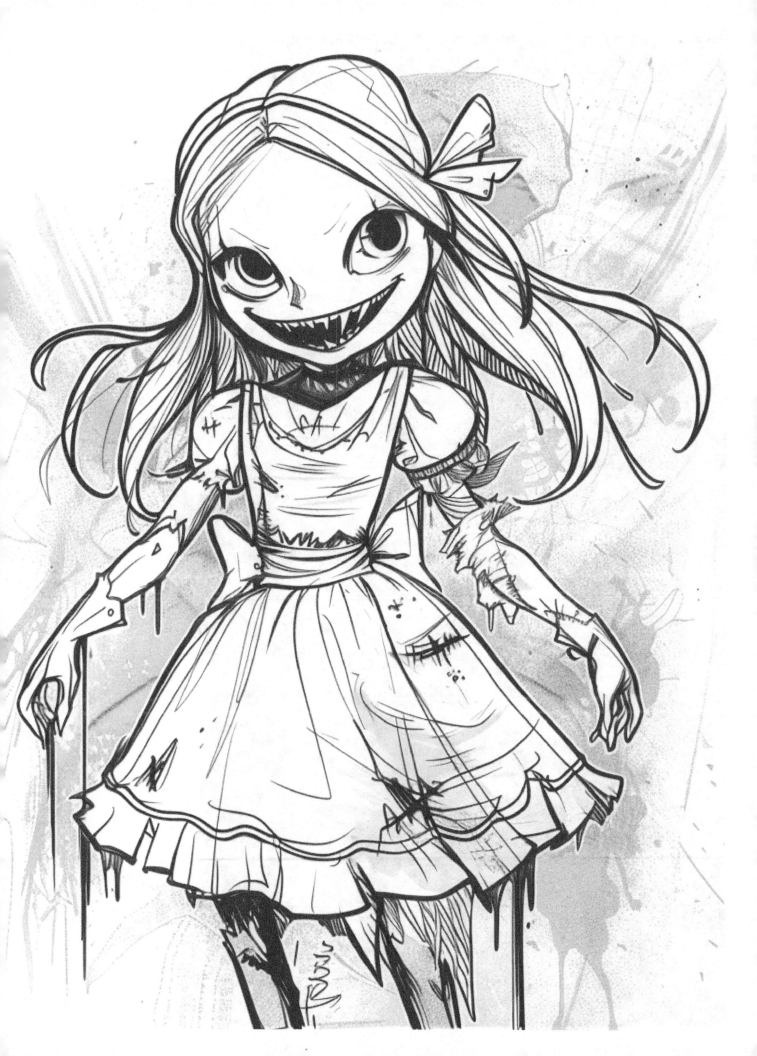

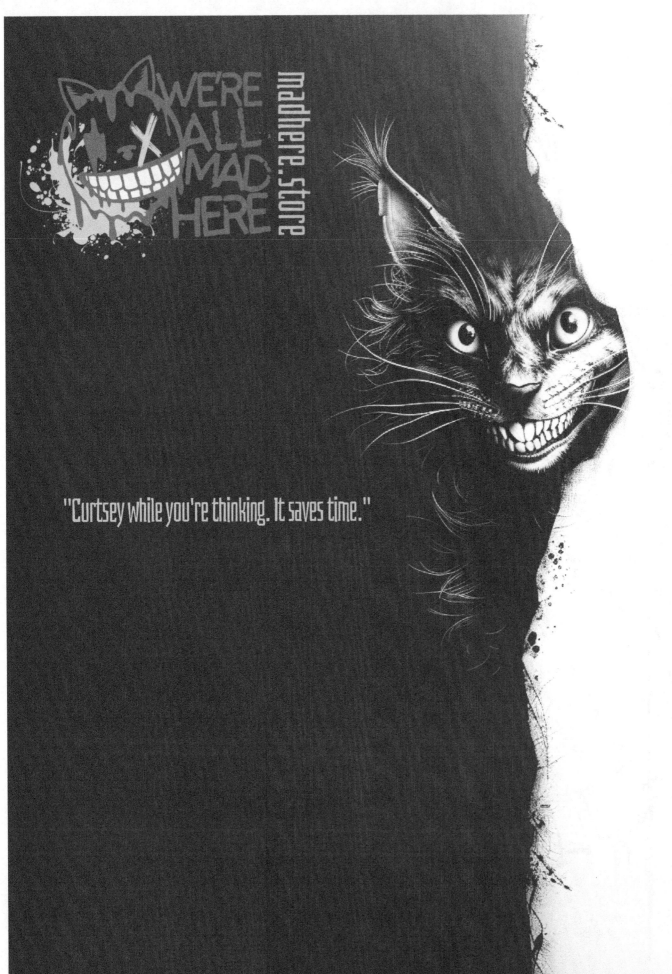

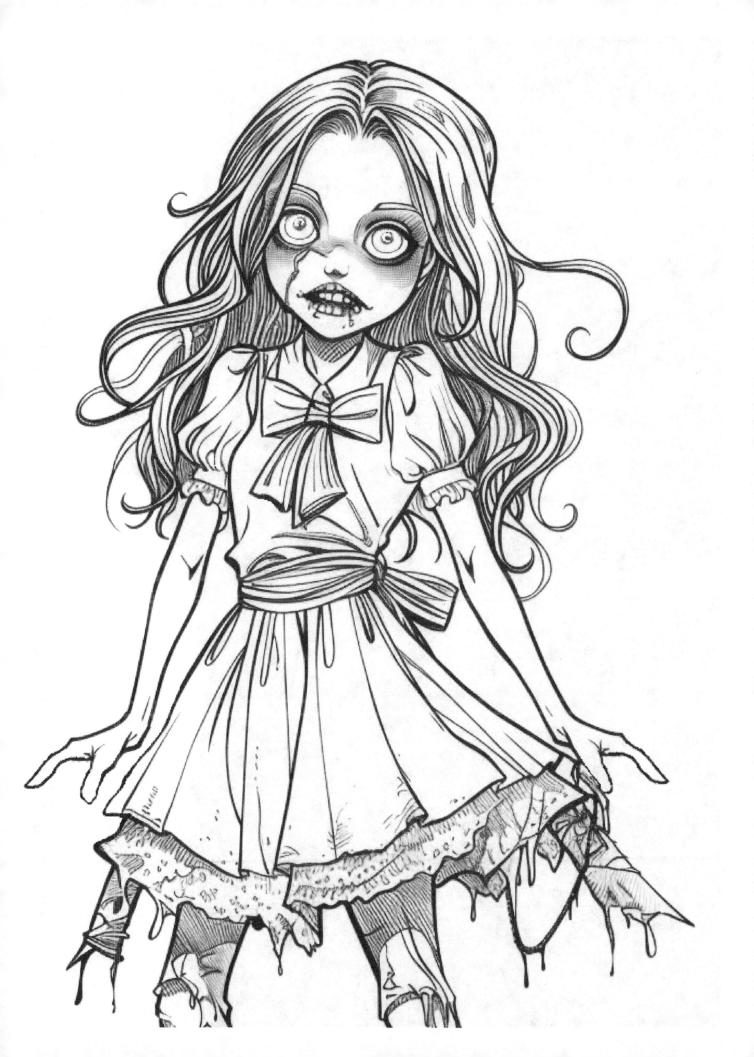

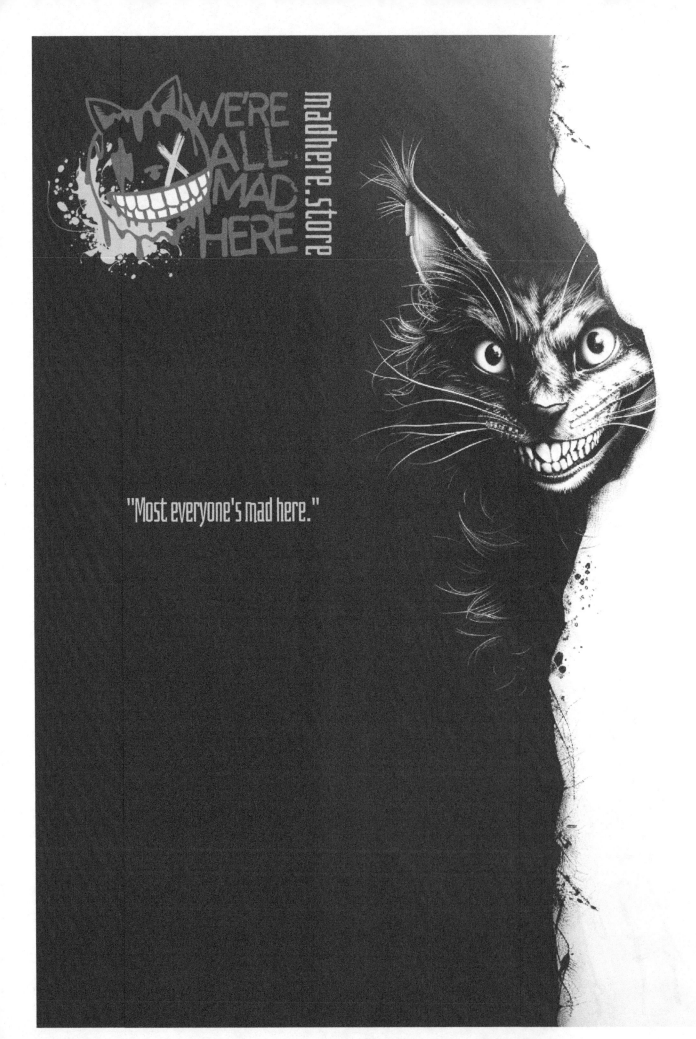

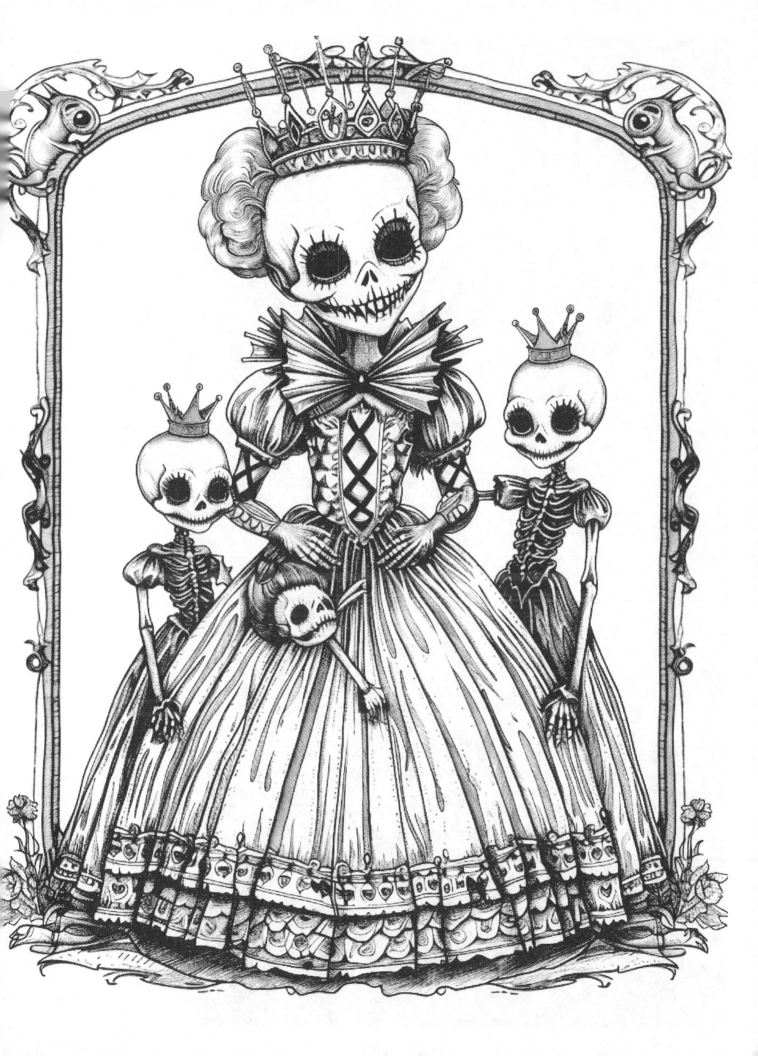

WE'RE ALL MAD HERE

madhere.store

"Well! I've often seen a cat without a grin, but a grin without a cat! It's the most curious thing I ever saw in all my life!"

ARE YOU READY TO COLOR OUTSIDE THE LINES OF REALITY?

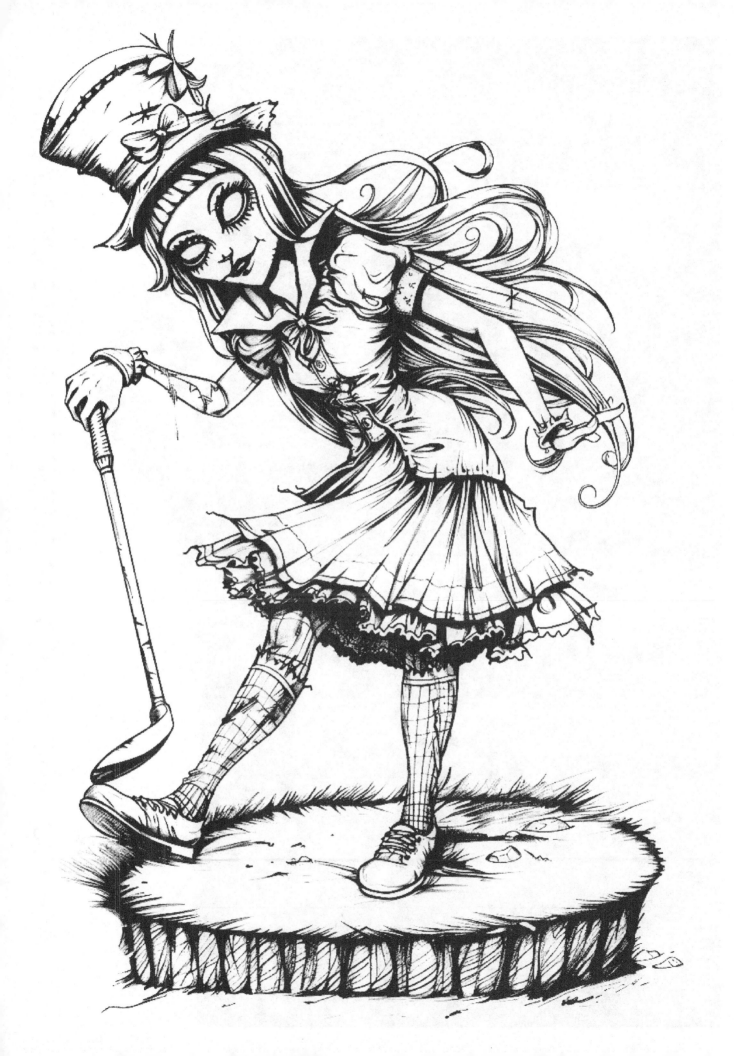

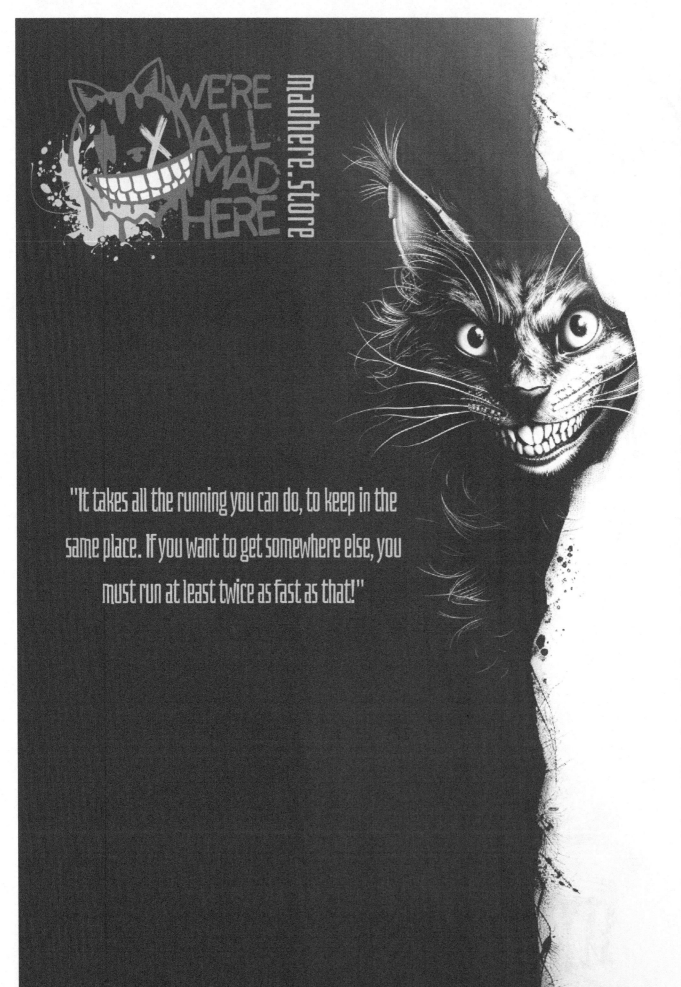

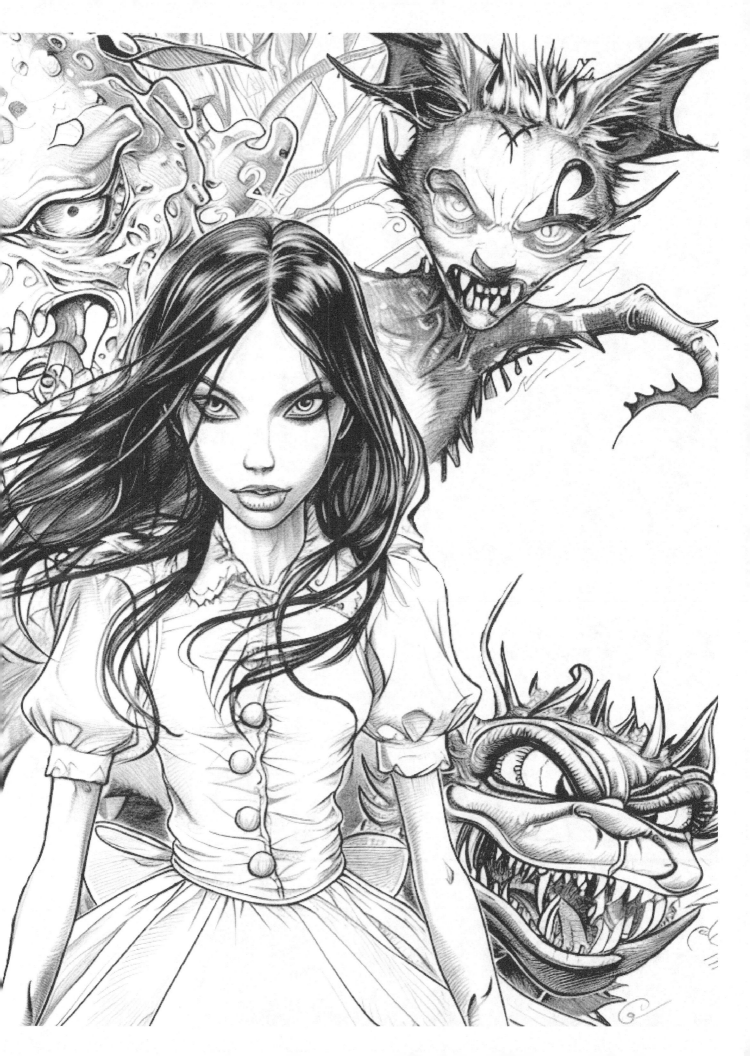

WE'RE ALL MAD HERE

madhere.store

"I'm late, I'm late! For a very important date! No time to say 'hello, goodbye,' I'm late, I'm late, I'm late!"

ARE YOU READY TO COLOR OUTSIDE THE LINES OF REALITY?

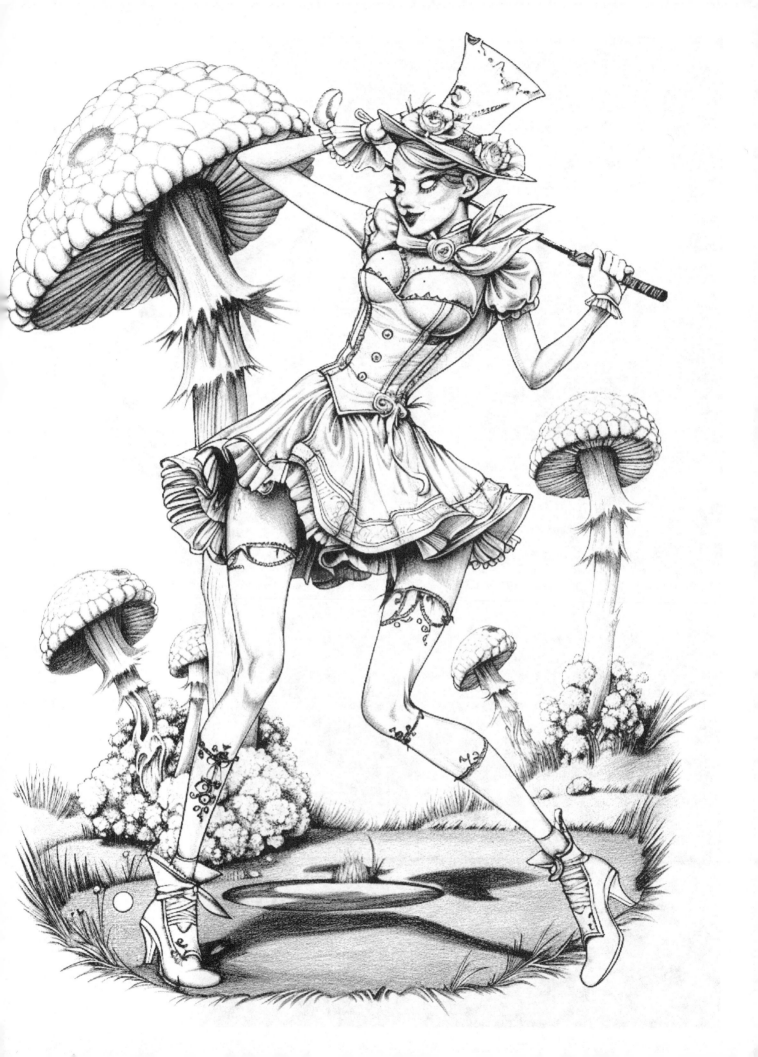

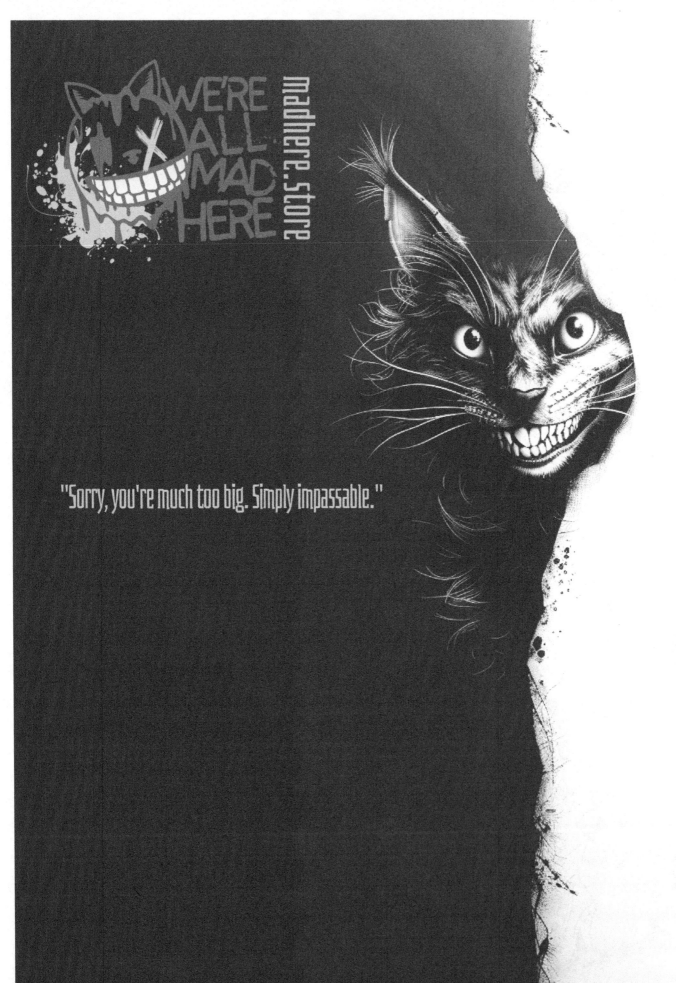

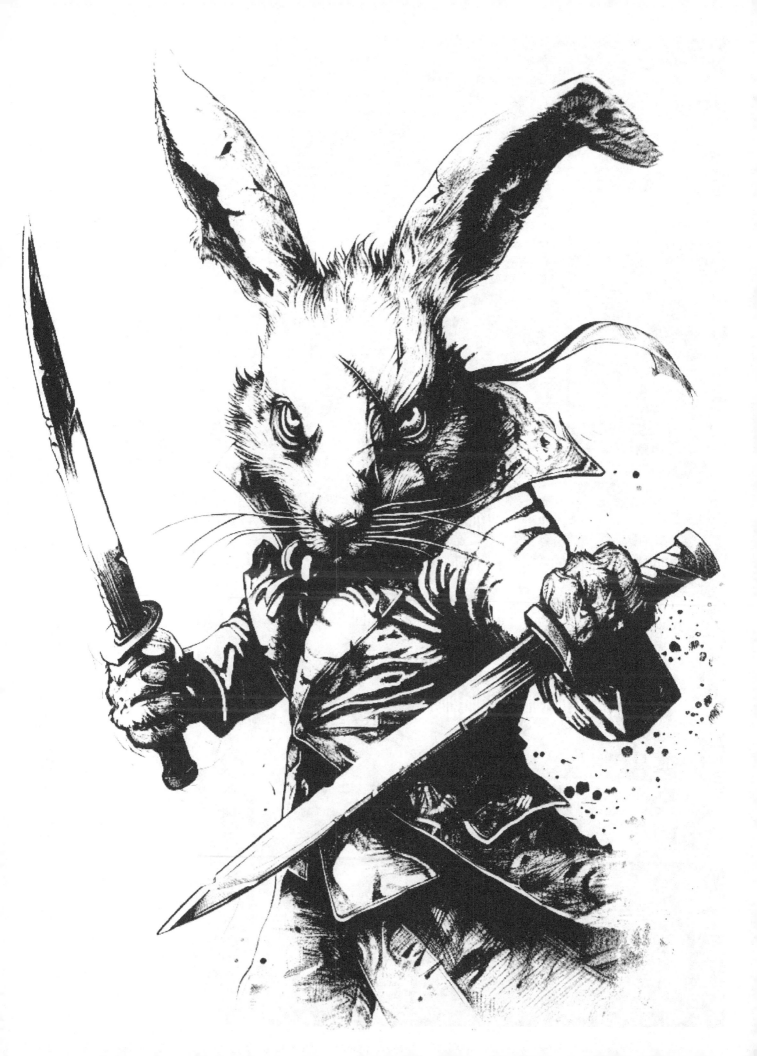

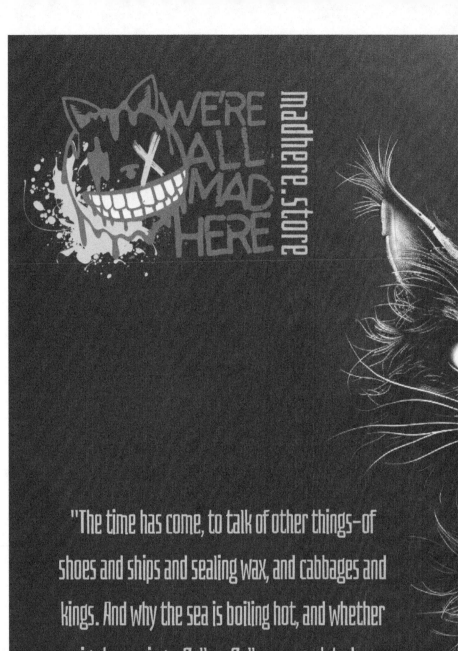

WE'RE ALL MAD HERE

madhere.store

"The time has come, to talk of other things–of shoes and ships and sealing wax, and cabbages and kings. And why the sea is boiling hot, and whether pigs have wings. Calloo, Callay, no work today, we're the cabbages and kings."

ARE YOU READY TO COLOR OUTSIDE THE LINES OF REALITY?

Don't be shy. we would love to see what you have created. share the images and your thoughts in the review section.

Our aim is to give you unique and high quality coloring books to challange your imagination.

Thank you for your purchase and your support! Mad Love!

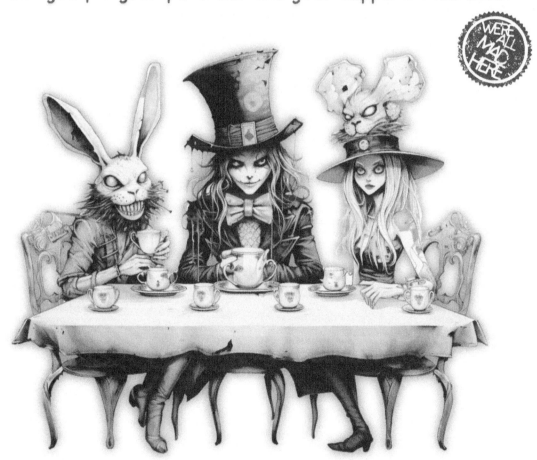

Made in the USA
Monee, IL
09 December 2024

72961834R00031